# Tim Gardner New Works

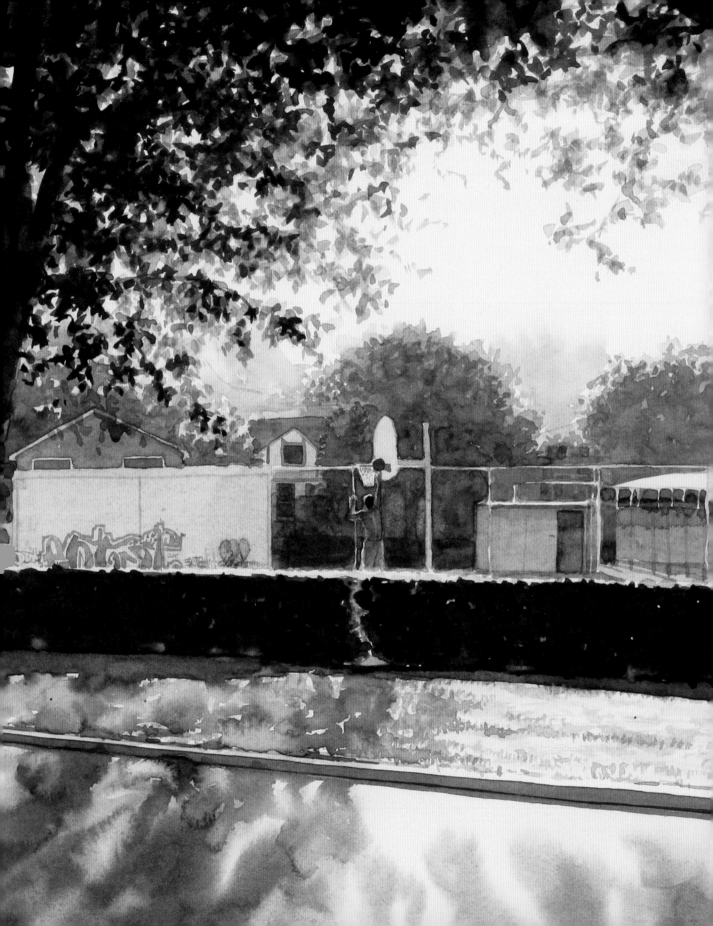

# Tim Gardner  New Works

Christopher Riopelle

**NATIONAL GALLERY COMPANY, LONDON**
DISTRIBUTED BY YALE UNIVERSITY PRESS

# Sponsor's Foreword

LOUISE MARLER SPENCE
CHAIR, CANADA HOUSE ARTS TRUST

When the National Gallery initially approached the Canada House Arts Trust about an exhibition of the work of contemporary Canadian painter, Tim Gardner, I discovered paintings of amazing clarity, almost photorealistic, painted in media most often associated with traditional painting – watercolour and pastel. The paintings that result, however, are anything but traditional. Their ambiguity beguiles us – seemingly innocuous scenes of two lads with a beer are somehow imbued with the emotion of youthful angst. The images Tim paints are often sent to him by friends and family, further removing him from direct involvement with the subjects. The paintings are startling and forceful in their impact.

Gardner spent three months in residence at the National Gallery, London, in the autumn of 2005. We congratulate the curator of the exhibition, Christopher Riopelle, and the National Gallery for their vision in including in this residency programme not only established artists, but also contemporary artists at the beginning of their careers.

We welcome the opportunity to sponsor Tim's catalogue. This exhibition exemplifies the goals of the Trust as we seek to support work that reflects the most exciting and innovative developments across the entire range of Canadian contemporary arts.

Tim Gardner's work is truly inspirational.

# Director's Foreword

CHARLES SAUMAREZ SMITH
DIRECTOR, THE NATIONAL GALLERY

The National Gallery has had a long and fruitful commitment to contemporary art over many years. Artists-in-residence and Associate Artists have made use of studio space in the Gallery, consulting the Collection as they see fit – often in exciting and unexpected ways – and then we have mounted consistently popular exhibitions of the works they have produced from the experience. Recently, under the auspices of our contemporary art committee, we have begun to expand the contemporary programme, holding at least one exhibition every year and inviting young and mid-career artists to spend briefer periods at the Gallery, as they prepare works for an exhibition. In this way the National Gallery associates itself more fully and directly with London's contemporary art scene.

Tim Gardner, a Canadian painter born in 1973 who works in watercolour and pastel, is the first of these young artists and was invited to spend three months at the Gallery, which he did on and off during autumn 2005. Gardner's career may be only beginning, but he has already established an impressive reputation through solo exhibitions at commercial galleries in New York and London. This exhibition of new works is already his second solo show in a public institution, following one in Indianapolis two years ago, and he is also increasingly represented in major public and private collections. His work is photo based, and resolutely contemporary in subject matter. None the less, it addresses the great themes that have long preoccupied the artists of the European tradition which the Gallery collects and displays. The remarkable ways in which Gardner extends that tradition recommended him to us, and the suite of 20 new works he has produced for this exhibition are beautiful, thoughtful and virtuoso displays of painterly skill.

Finally, at the National Gallery, we are grateful to the Canada House Arts Trust, the 303 Gallery, New York, and Stuart Shave/Modern Art, London, for their support of the exhibition and to Christopher Riopelle, who has overseen all aspects of the organisation of the exhibition, as well as writing the catalogue's text.

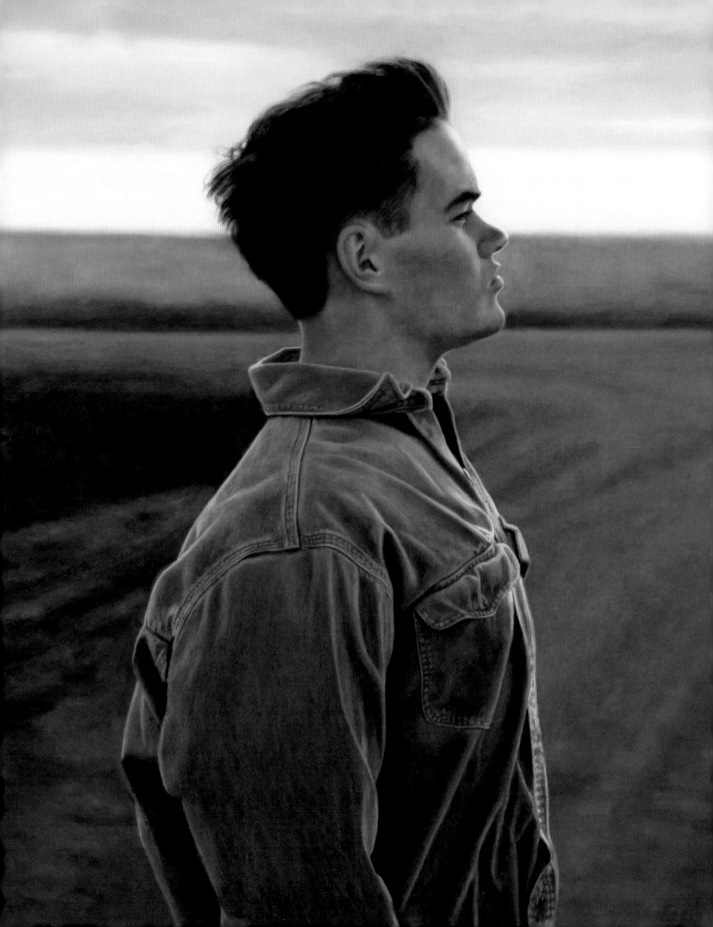

# To the Mountain and Back

CHRISTOPHER RIOPELLE

In 2003 Tim Gardner painted a watercolour based on a photograph of a semi-professional ice hockey team from Waterloo, Ontario, of which he is a fan. *Untitled (Waterloo Siskins)* (overleaf) is a good introduction to the themes and methods of Gardner's art. Wherever the game is played, there is no more conventional and familiar an image than the ice hockey team photograph. They follow a pattern; players, coaches and assistants are arranged on the ice rink in three rows, the team captain sits dead centre while heavily padded goal keepers – goalies in Canadian parlance – flank the front row. Sometimes a national emblem, here a Maple Leaf Flag, dips from the rafters, but everyone looks at the camera, awkward with the self-consciousness that being photographed can induce. Hundreds of teams sit for such shots every year and to the disinterested observer they all look pretty much alike.

The hockey fan sees it differently. He – or she; but this is primarily a man's world – recognises the players as individuals, knows their names and how their playing season has fared, how many wins and losses they have had, and against which rivals. He appreciates the camaraderie that infuses the team and empathises, often raucously from the stands, with the pursuit of the common goal that once or twice a week at game time unites them all in sport. However stereotypical the form it takes, for the fan the team photograph is distinctive, complicated, an emotionally charged artefact that comes to commemorate a shared set of hopes raised or crushed. It also registers a kind of longing, for who would not want to be on that team, share those friendships, bask in the flush of youth?

It is Gardner's talent to see such emotional resonance in even the most seemingly banal photographic images. He has been doing so since the start of his still-young artistic career a decade ago. Snapshots of family and friends and the (unmistakably North American) world they inhabit have provided him with

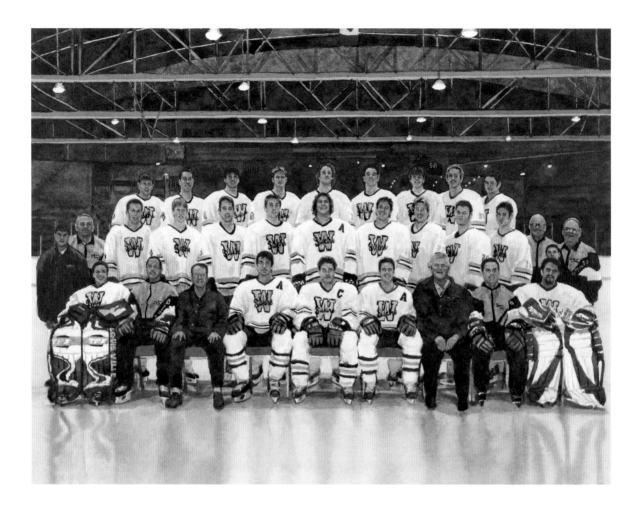

**Untitled (Waterloo Siskins)**, 2003
Watercolour on paper,
27.5 × 32.5 cm
Private collection

an exceptionally rich range of motifs with which to investigate contemporary middle-class life. The exploration of male friendship, as here, has long been a concern. Youthful excess was an important early theme investigated in paintings of drinking binges and carousing. As he himself has grown older this has retreated, superseded by a growing concern with family and with our relationship to nature. From the beginning, however, Gardner's art has constituted an act of rigorous attention. He coaxes meaning out of the images he chooses by recreating them in a different medium: pencil, pen and ink, watercolour or pastel. By meticulously replicating the hockey team photo in watercolour, for example, by focusing the full intensity of his eye and

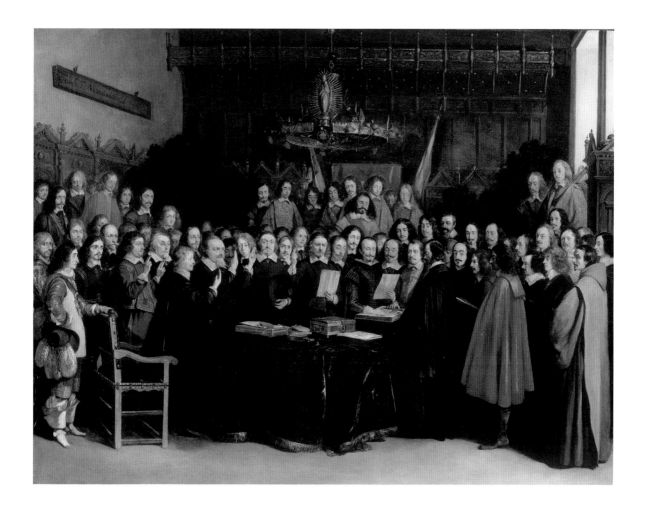

mind upon it, by bringing to bear considerable skill in the manipulation of his chosen medium – and sheer technical virtuosity is a notable aspect of his art  he begins to make explicit what is latent in the image. Indeed, the very act of replicating the photo alters it. Tensions the camera did not know it was registering stealthily emerge. Details of gesture or glance, signs of fear or bravado, those minutiae of human interaction that capture Gardner's attention as he scans the photo, are somehow magnified and made more intense, as he renders them on paper. (As the *New Yorker* asked of the psychological undercurrents evident in a recent series of pastels Gardner based on otherwise innocuous family portraits: 'How do any of us survive?')

Gerard ter Borch (1617–1681)
**The Swearing of the Oath of Ratification of the Treaty of Münster**, 1648
Oil on copper, 45.4 × 58.5 cm
The National Gallery, London

Here, Gardner captures the modest, optimistic heroism of the hockey team, cheerful warriors on a circumscribed sheet of ice. They are young men who, one assumes, go about their workaday rounds as builders or car salesmen or clerks but who also share this other, sporadically exalted, team life where together they bid for victory. Youth and strength pass; athletic prowess fades; things may never be this good again. Do we detect a trace of resignation in the way the gloved hands of the captain droop below his knees, in his disinclination to smile? Unlike the players, the older assistants flanking them do not wear ice skates; do they feel as diminished as they look to us next to the wall of youthful virility towering over them? The digital clock near the roofline ambiguously records the time as 5:21 which may be late in the afternoon or very early in the morning; in Canada you play or practise whenever you can book the rink. Gardner's art asks those of us who know nothing about the Waterloo Siskins none the less to attend to such matters in deeper, more thoughtful ways than the original photo would ever be likely to provoke.

We live in reduced times and heroism is a rare theme in contemporary art, heroism of a collective kind rarer still, but its commemoration was once considered to be a high calling for the artist. Conceptually, Gardner's painting recalls the Old Master tradition of group portraiture as it flourished in seventeenth-century Holland. There, it celebrated the deeds of prosperous Dutch burghers who, acting in unison, advanced the interests of their Republic. An example in the National Gallery's collection is Gerard ter Borch's *The Swearing of the Oath of Ratification of the Treaty of Münster* (page 9). Here too ranks of ordinary men proudly, if somewhat awkwardly, gather together to mark a turning point, the oath sworn by Holland and mighty Spain in 1648 to end 80 years of conflict. It was important for the Dutch that this event and its participants be recorded and remembered. Small in scale, sober, without baroque flourishes but paying close attention to the specificities of the occasion, to this day ter Borch's painting has a special intensity of meaning for the Dutch (which is why it hangs not in the National Gallery but on long-term loan to the Rijksmuseum in Amsterdam). Slow, detailed and labour-intensive, group portraiture as ter Borch and his contemporaries practised it has all but disappeared from painting today. With *Untitled (Waterloo Siskins)* Gardner bids to revive the genre in contemporary terms, not by imitating the Old Masters but by looking at how photography of the most conventional and prolific kind deals with the subject and then producing a painting that is at once deeply sympathetic and coolly analytical, a profound meditation on

friendship, masculinity and youth. He stands in a line of photo-based painters that includes late Sickert, Warhol and Richter, among others, for whom the simple snap or pedestrian publicity shot can open up worlds of meaning.

Gardner's painting is far more than the formal relationships of line and colour he employed in its making; it remains intricately mixed up with life. The reason he chose to paint it is because the source photograph carried a charge of meaning for him. On the other hand, Gardner is first and foremost a painter: he does not want to fool us into thinking *Untitled (Waterloo Siskins)* is indeed a photograph. The reflections on the ice in front of the team are a masterful invention in thin washes of colour, as are the bluish shadows that play across the players' white jerseys. Such details call our notice back to the medium and to Gardner's control over it; he wants us to know he has crafted this image. Artistry of a high order is always evident in Gardner's work and captures our attention as fully and compellingly as its thematic richness.

---

It is this glancing relationship of Gardner's art to Old Master painting, the oblique way in which he addresses its themes in contemporary terms, which led to his invitation to spend time at the National Gallery in autumn 2005 and to mount an exhibition. That he employs traditional media such as watercolour, about which a British audience is as knowledgeable and discerning as any, also suggested that the encounter might prove fruitful. The 20 new watercolours and pastels in the show, all completed during or since his stay, fall into four categories, scenes set on buses, Rocky Mountain and prairie vistas, family portraits, and views of the banal and generic suburbs of Victoria, British Columbia, on Vancouver Island, where Gardner lives. At first glance nothing suggests a relationship with the National Gallery and its paintings, nor indeed with London. The works are based on photographs, many of which were taken long before his time in the Gallery. Their subjects are instantly recognisable as not-British, not-European, 'low' rather than 'high', to make the distinction often drawn in discussions of modern art and its sources. You don't get much 'lower' than a Kentucky Fried Chicken logo (page 37)! Nor at first glance is there any immediate sense that the works cohere as a group. Only slowly does it emerge how carefully Gardner looked at what he saw in the Gallery, how rich and nuanced his response has been, how focused and rigorous a suite of paintings this is.

Caspar David Friedrich
(1774–1840)
**The Wanderer above a Sea of Mist**, 1818
Oil on canvas, 94 × 74.8 cm
Kunsthalle, Hamburg

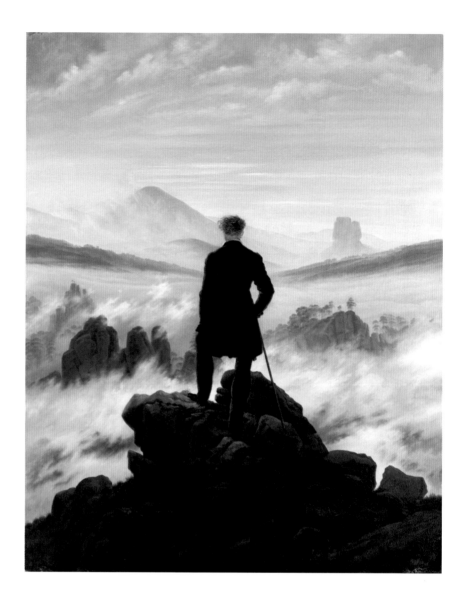

Gardner very rarely makes direct quotations from Old Masters, though he is a frequent and attentive visitor to museums and galleries. He does not paint 'like' any particular artist of the past. The viewer will not find borrowings from this specific Velázquez painting or that Delacroix, as one does in the works of, say, Picasso. Such allusions would seem forced and 'arty' in the context of the middle-class North American culture he studies. A partial exception perhaps

is Gardner's repeated use here of figures seen from the rear as they gaze off across expanses of water or into mountain landscapes, as in *Skier* (page 20), a watercolour that shows a figure who slows for a moment high on a mountain to lean forward on his ski poles and look at the white-capped peaks and overcast sky beyond. This is a simple pictorial device that ultimately derives from Caspar David Friedrich, the German Romantic artist, who in the early nineteenth century first explored its implications in such works as his 1818 painting *Wanderer above a Sea of Mist* (opposite). Because facial expressions are hidden, we cannot help but project our own meanings onto these backs, imagine the figures' responses to the grand and powerful vistas they survey. As Friedrich understood and exploited, they become the viewers' surrogates through whom we too contemplate the landscape, approach the sublime. In fact, *Skier* derives from a photo in a glossy skiing magazine. Its relatively pedestrian origin is typical of Gardner's choices. Moreover, Friedrich's pictorial innovations have long since been absorbed into popular culture, used for the promotion of tourism and leisure activity, but this is part of Gardner's point.

The first picture in the exhibition, completed at the National Gallery, *Skier*, introduces a major theme, indeed the leitmotiv of the exhibition, what Gardner sees as a crisis in our relationship with nature at its grandest and most sublime, the necessity of our continuing to contemplate it but increasing inability to do so. How is it possible to have a direct and authentic confrontation with nature when it has been mediated for us by so many layers of advertising and generations of television and movie imagery? Can we be anything less than self-conscious when we look at towering mountains, just because we know we are meant to be having sublime and elevating thoughts, and yet sometimes they just do not come? The skier he depicts could not even have reached such a site without the purchase of expensive sports equipment, a day pass to a costly ski resort, the highway that had to be put in so he could drive there. Gardner returns to such figures seen from the rear repeatedly in the exhibition, sometimes with single figures (see pages 26 and 32), sometimes with groups. They punctuate it at regular intervals, returning us repeatedly to the question that lies at its heart and intensifying its implications.

One watercolour, a haunting silvery seascape showing a man gazing out across a vast expanse of ocean at night, is called *Figure watching the Moon* (page 38). Both the image and its title call to mind one of Friedrich's most haunting compositions, *Two Men contemplating the Moon* (there are various versions)

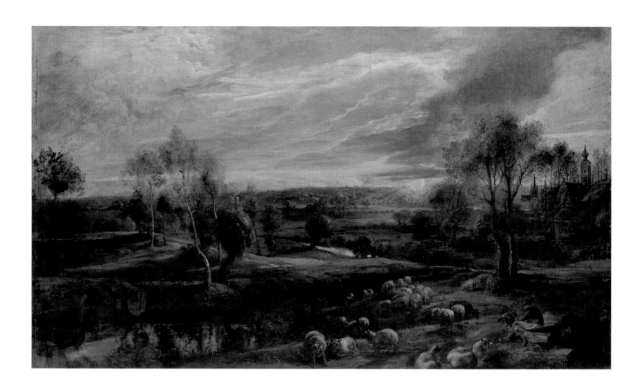

Peter Paul Rubens (1577–1640)
**A Landscape with a Shepherd
and his Flock**, about 1638
Oil on oak, 49.4 × 83.5 cm
The National Gallery, London

but that dying fall from 'contemplating' to merely 'watching' tells its own tale of increasing alienation from nature's mysteries. The German master is evoked once again in *Sunburst over the Prairie* (page 35). Gardner studied the National Gallery's only Friedrich painting, *Winter Landscape* of 1811 (NG 6517), noting the blades of grass poking through the snow around the seated pilgrim at its centre. He also raised a sceptical eyebrow at the Gallery's up-beat interpretation of the motif as evidence of new life irrepressibly surging from the earth. Gardner has lived on the Canadian Prairies and has seen the same motif after the harvest when winter has begun to set in. That grass is dead, he declares succinctly; the snow has simply not covered it yet. His landscape with its snow and dry husks of grass explicitly 'corrects' Friedrich's painting, or at least the Gallery's take on it, reminding us that, like Friedrich, his depiction of nature is based on long observation and immediate experience.

The magnificent effect of sun bursting through towering grey clouds that takes up three-quarters of that sheet also derives from observations of natural phenomena particular to the Prairies. At the same time it is an imposing free-form

improvisation in watercolour, an almost abstract composition in watery washes of pigment. (It should be pointed out that all of Gardner's watercolours here are painted with recycled rainwater so that they themselves participate in the cycles of nature.) Among the artists Gardner looked at longest in the National Gallery was Peter Paul Rubens, and of Rubens's works he was especially interested in the landscapes. He saw how in paintings like *A Landscape with a Shepherd and his Flock* the Flemish master was able to enhance the mood of the picture by introducing dramatic incident into the sky, in this case scudding cloud and flashes of light at the horizon. He also spent time in the drawings rooms of the British Museum and Tate Britain, studying Turner and Constable, for whom clouds were essential pictorial components. Clouds and diurnal and nocturnal light effects have long played an important role in Gardner's art, but perhaps one impact of his stay that marks many of his recent works has been the increased breadth of vision in his handling of skies.

Other paintings here expand on Gardner's preoccupation with what he perceives as our failing relationship with nature. Two large pastels are set on moving buses. In one, *Into the Rainbow Vein* (see page 22) – the title comes from a song by the innovative Scottish group Boards of Canada – a melancholic young traveller nods off oblivious to the rainbow that arches across the sky, oblivious to the category of the sublime that was long held in Western thought to reside in nature. In the other, *Two Men on a Bus, moving through the Landscape* (page 25) middle-aged men ignore the mountain peak and towering clouds outside the bus window, which are of a kind tourists ostensibly travel to the Canadian Rockies to see. The picture is a composite. Gardner snapped the men on a tour bus heading to the Indianapolis 500 Speedway in Indiana, a destination rarely associated with the sublime; one of them has just realised he is being photographed and does not seem pleased. The landscape beyond, however, is indeed based on a photograph of the Rockies. The same peak appears in *Road through the Rockies* (page 24) but there our access to it is mediated by the slash of highway and barrier rail that cuts through the landscape and across the bottom of the sheet. The roadway takes us there but at the same time keeps us away.

Specific mountains and sites in the Canadian Rockies, all rendered with superb attention to detail, figure prominently in the exhibition in works like *Road into Emerald Lake* (page 21), a study in subtle green tints, and *Mount Edith Cavell* (page 29). Is the latter a sly reference to Gardner's stay at the National Gallery?

The memorial statue of Edith Cavell, martyred in the First World War, stands at the foot of Charing Cross Road only a hundred feet or so from the studio he occupied here. In any case, the Gallery is one of the great repositories of the European landscape tradition, including paintings of the utmost grandeur and power by Rubens, Claude, Turner and others. Can this tradition survive, Gardner's paintings ask, can we connect with nature in the same authentic way as we once did in the current world of corporate consumerism, mass tourism and the onslaught of simulated experiences? Gardner has his doubts.

Why this intense preoccupation with mountains? Why for that matter has Gardner also included family portraits like *Jim in Sun* (page 28), a glowing, almost beatific image of the artist's father? In fact the two questions are one and the same. James Gardner is a university professor of geography who has taught in Canada and the United States, including Iowa where Tim Gardner was born, and is a widely recognised authority on the geomorphology, or formation and evolution, of mountains. From childhood Tim, his mother, and brothers Nick and Tobi spent summers in the mountains, from the Rockies to the Himalayas, while their father was conducting research. They know mountains, their personalities and vicissitudes in an intimate and immediate way. They care about them as a family. For Gardner, *Mount Edith Cavell* and the others are as much *portraits* as any depiction of a family member or friend – if by 'portrait' we mean the characterful representation of a set of individual, defining features. Mountains are where, for Gardner, family concerns meet public and artistic issues like the environment and the future of landscape painting.

All three Gardner sons appear here, and their portraits in pastel are among the most arresting of Tim Gardner's recent works. In *Tobi on the Red River* (page 33), the youngest boy is like a mythological figure, Cyclops in the guise of a dude, his large dark sunglasses reducing him to a single enormous eye that casts an appraising stare. (Note the remarkable transparency Gardner achieves in pastel, depicting the edge of Tobi's face through the shades.) He wears his baseball cap like the cool guys used to, in North America anyway, back to front – Gardner took the photo on which the portrait is based several years ago – and appears set to come out with one of those sarcastic comments kid brothers inevitably make. There is a rueful affection at work here. Gardner's *Self Portrait* (page 27) has a brooding concentration to it as he turns narrowed, inquiring eyes toward the viewer. With shaven head and face half in darkness, he is like a bonze, or Buddhist monk, or rather like Vincent van Gogh in the guise of a

bonze in his own ferociously intense *Self Portrait* (Harvard University Art Museums, Cambridge, MA). But the hood on the back of his sweats reminds us of the contemporaneity of the image too. Most remarkable – the word monumental would not be misplaced – is *Nick on the Prairie, facing into the Wind* (page 34), showing Gardner's older brother in profile, indeed endowing him with the gravity and power of an ancient Roman emperor. At the same time, it evokes the mythology of the North American West and the rugged, strong individuals who are held to have settled it a century ago. This is a Marcus Aurelius of the Prairies. Again, Gardner took the picture it is based on some time ago – it is a posed photo as opposed to a snapshot, the only such photograph Gardner has taken and then used for a painting – but did not know quite what to do with it. He painted it after his National Gallery sojourn and exposure here, however subliminal, to centuries of paintings that analyse power, individuality and the heroic. It is a final confirmation of the seriousness of purpose Gardner brings to his art.

But it is not the final work here. The series ends on a more mundane note with paintings of Victoria, BC, including the aforementioned KFC advertising sign, and another image of the utterly nondescript Canwest Mall in the suburbs of the city (page 36). But note the rare and tranquil beauty of the fading evening sky that casts a beneficent glow across the landscape. Gardner is sounding a gentler note here, investigating not the grandeur and splendour of nature at its most awesome but the quiet, fleeting harmonies of the city and of ordinary everyday life. In one of his most beautiful paintings, *Oak Bay Basketball* (page 39) a young man, shirt off, shoots hoops alone on the court of a suburban park amid the lengthening shadows of a late afternoon in summer. Graffiti, the inevitable adornment of the modern world, spreads across an adjacent wall. (Gardner actually copied the motif from markings on a wall he can see from the rear window of his studio in downtown Victoria.) The painting offers us a glimpse of solitude and its simple pleasures. It is a kind of suburban pastoral glowing with the inner warmth of a painting by Claude.

Tim Gardner's remarkable new cycle of paintings takes us on a journey, up from town and our commonplace lives into the mountains in search of . . . something. The sublime? An authentic experience of nature's power? True connection with family, friends? We may not find what we are looking for – the note of elegy is strong here – but we come back down from the hills at the end of the day to, well, carry on as best we can.

# Catalogue

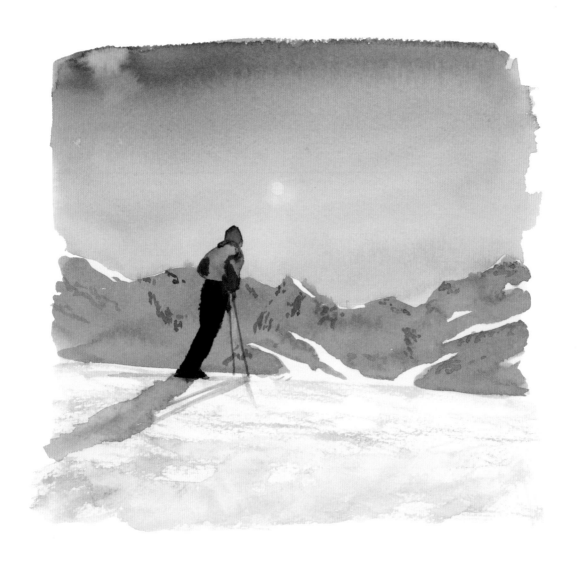

**Skier**, 2006
Watercolour on paper, 20.3 × 20.3 cm

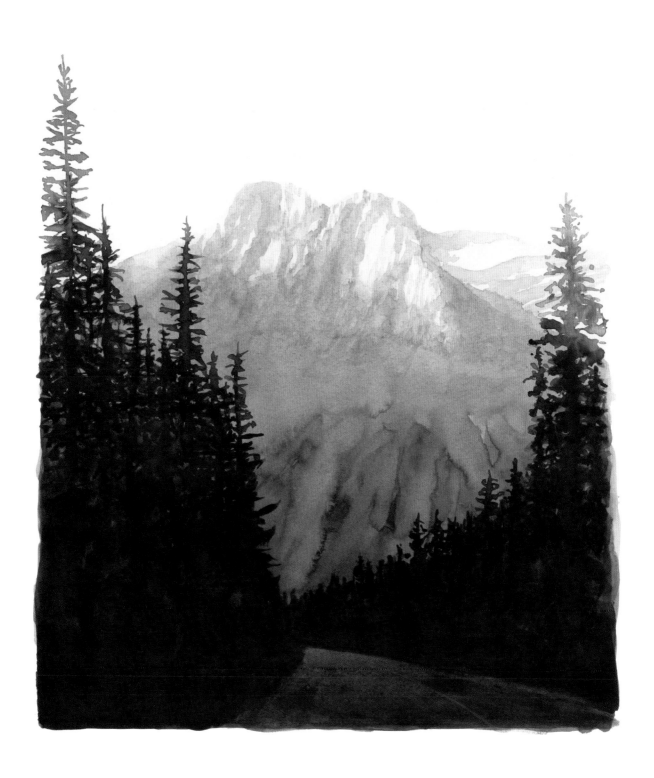

**Road into Emerald Lake**, 2006
Watercolour on paper, 43.8 × 37.5 cm

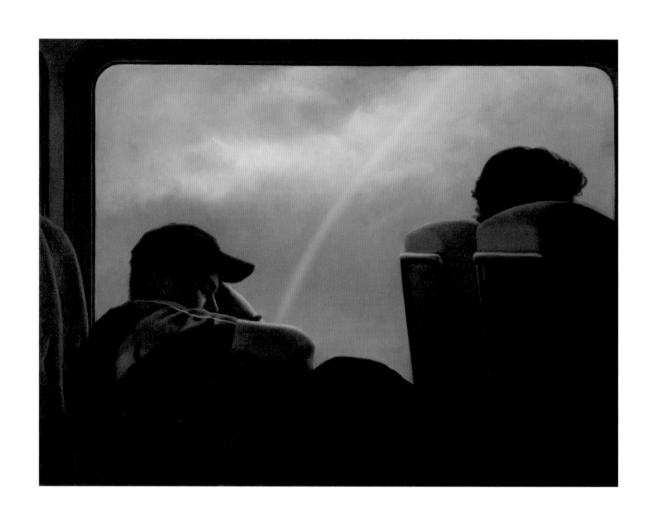

**Into the Rainbow Vein**, 2006
Pastel on gessoed paper mounted on canvas, 96.5 × 127 cm

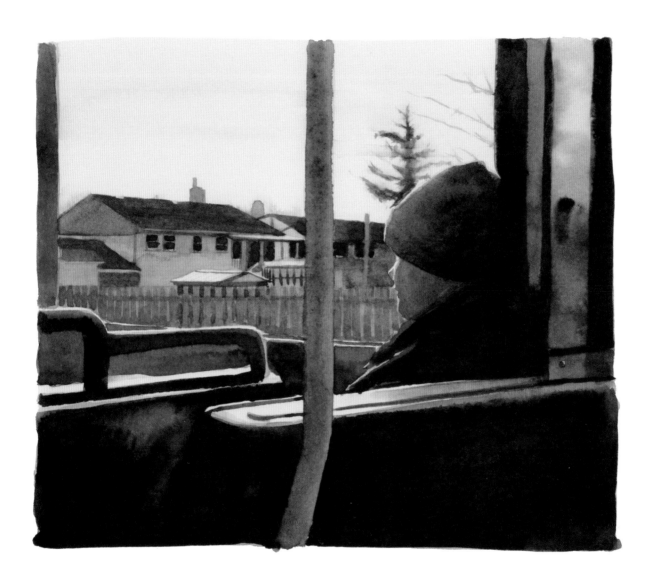

**Boy on a Bus**, 2006
Watercolour on paper, 17.8 × 20.3 cm

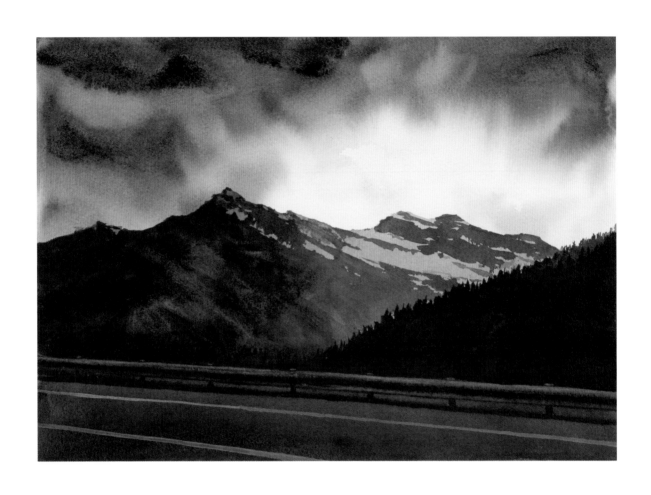

**Road through the Rockies**, 2006
Watercolour on paper, 25.4 × 35.6 cm

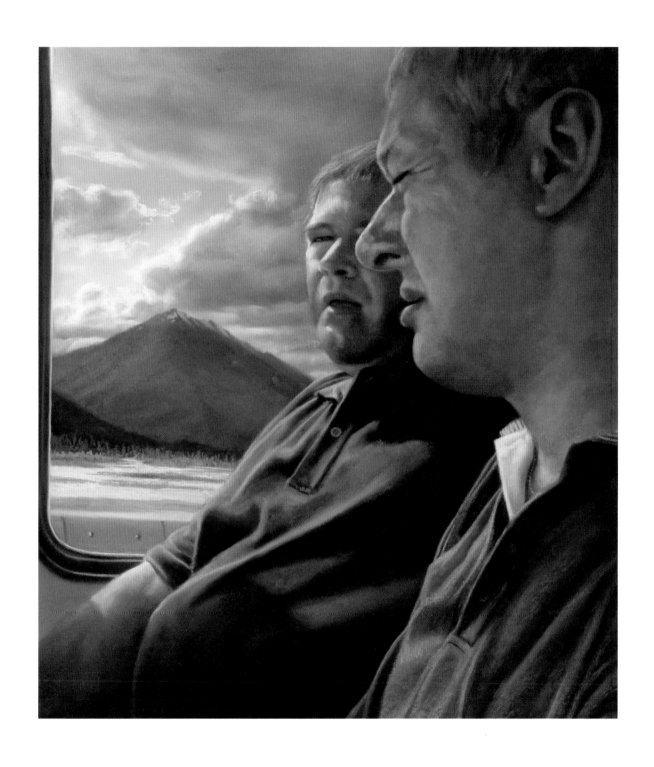

**Two Men on a Bus, moving through the Landscape**, 2006
Pastel on paper, 62.9 × 55.9 cm

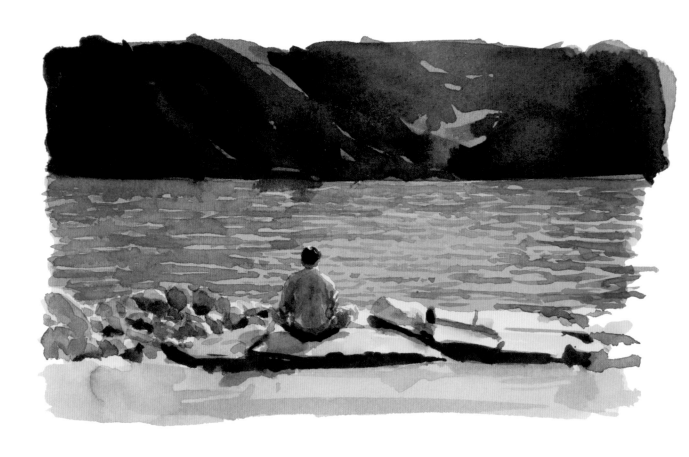

**Tobi by the Lakeshore**, 2006
Watercolour on paper, 11.4 × 18.4 cm

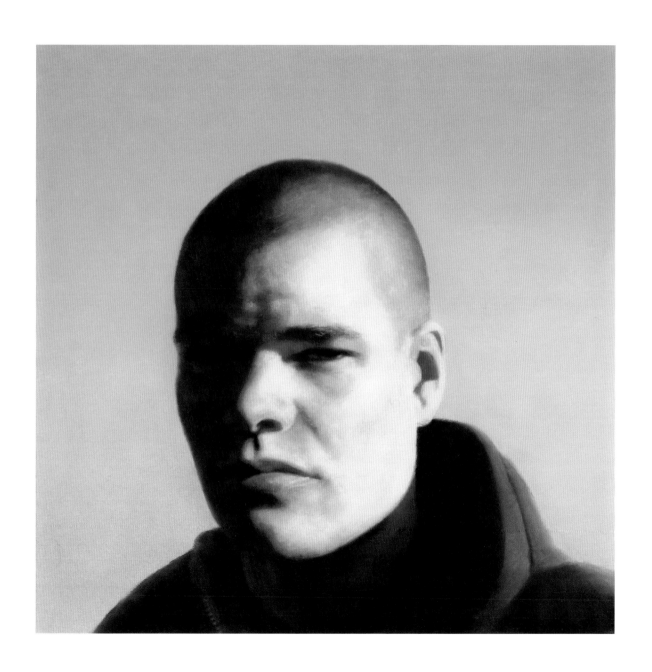

**Self Portrait**, 2006
Pastel on paper, 40.6 × 40.6 cm

**Jim in Sun**, 2006
Pastel on paper, 35.6 × 30.5 cm

28

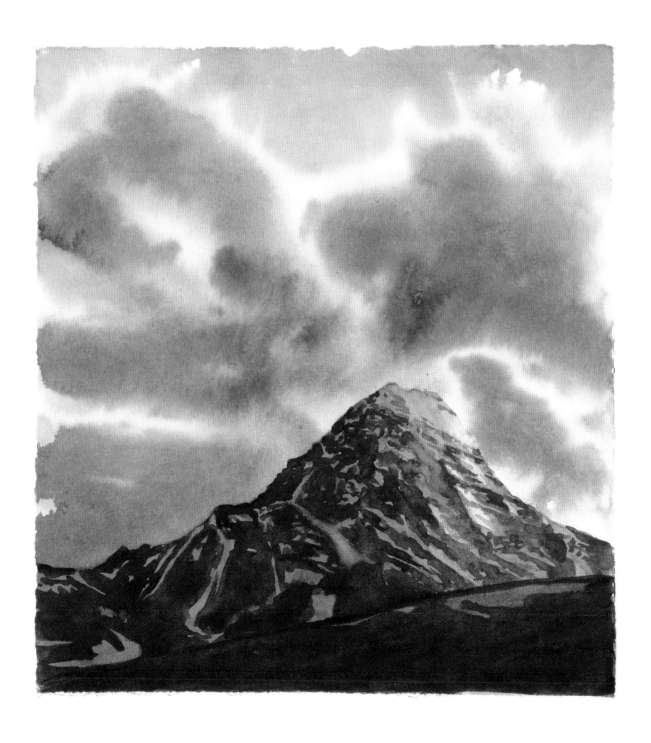

**Mount Edith Cavell**, 2006
Watercolour on paper, 26.7 × 24.1 cm

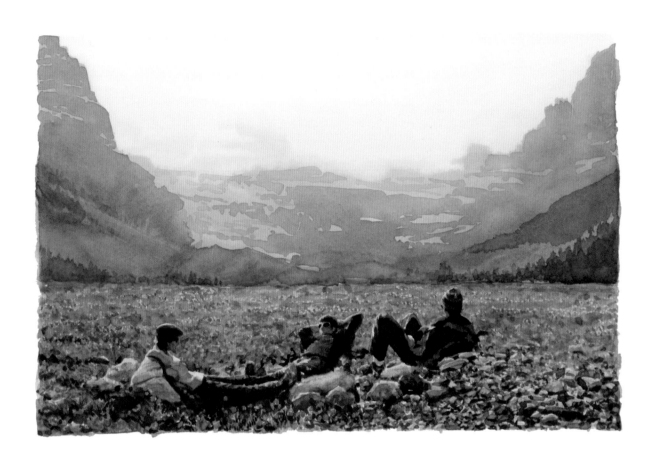

**Young Men on a Plain**, 2006
Watercolour on paper, 17.8 × 23.5 cm

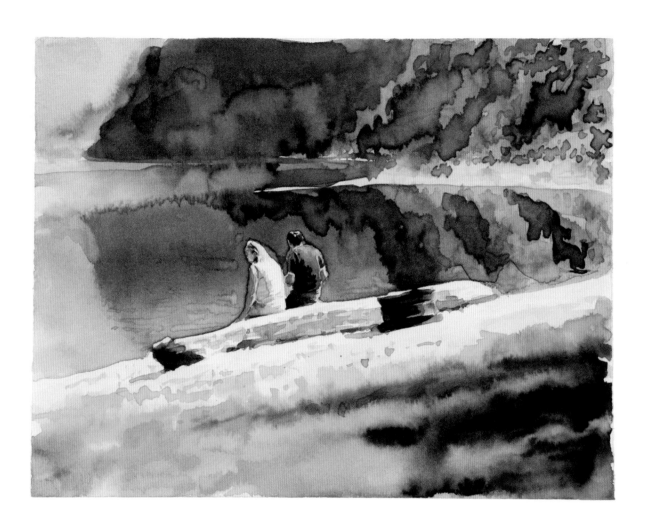

**Couple by a Lake**, 2006
Watercolour on paper, 16.5 × 21 cm

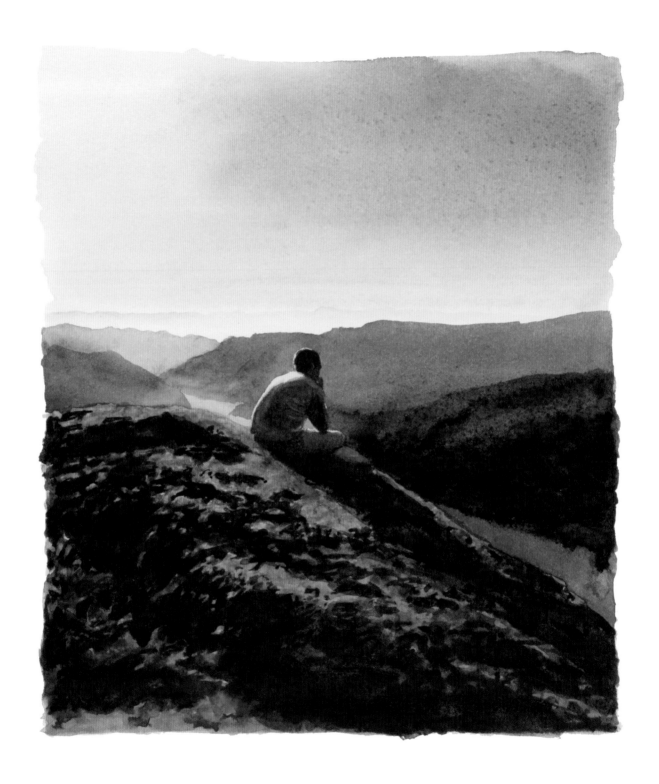

**Untitled (Tobi in the Landscape)**, 2006
Watercolour on paper, 21.6 × 18.4 cm

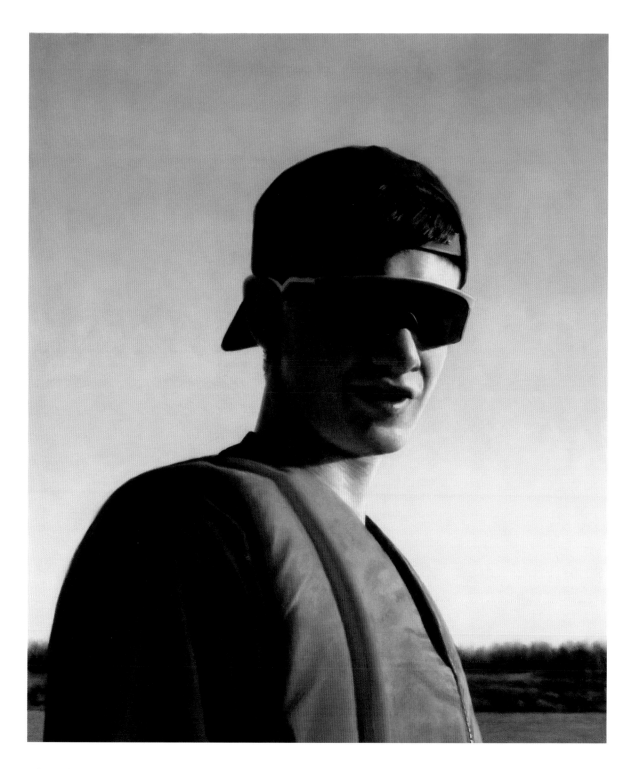

**Tobi on the Red River**, 2006
Pastel on paper, 86.4 × 71.1 cm

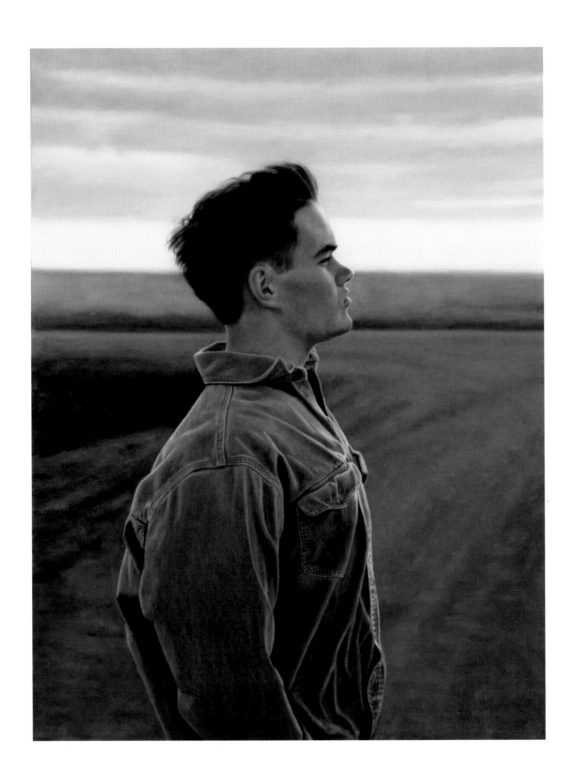

**Nick on the Prairie, facing into the Wind**, 2006
Pastel on gessoed paper mounted on canvas, 127 × 96.5 cm

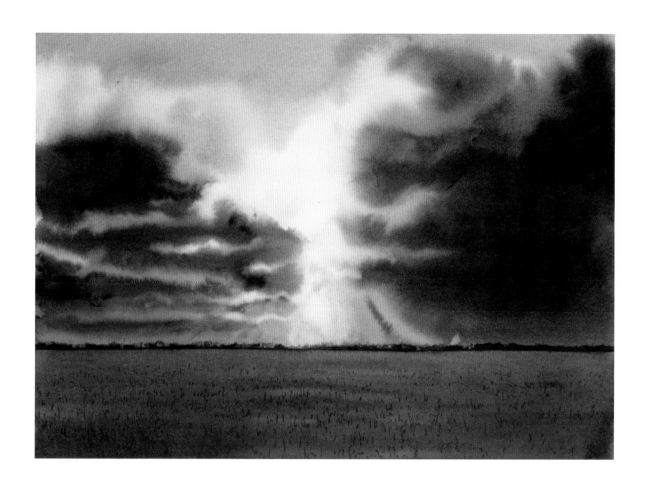

**Sunburst over the Prairie**, 2006
Watercolour on paper, 26 × 35.6 cm

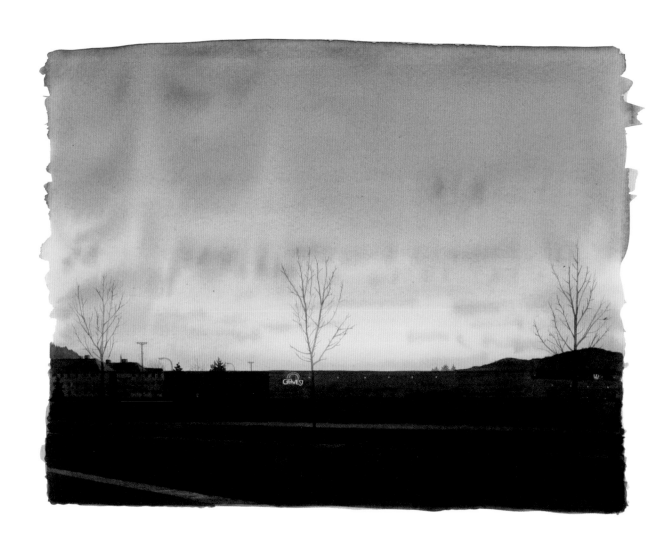

**Canwest Mall, Evening**, 2006
Watercolour on paper, 28 × 38.1 cm

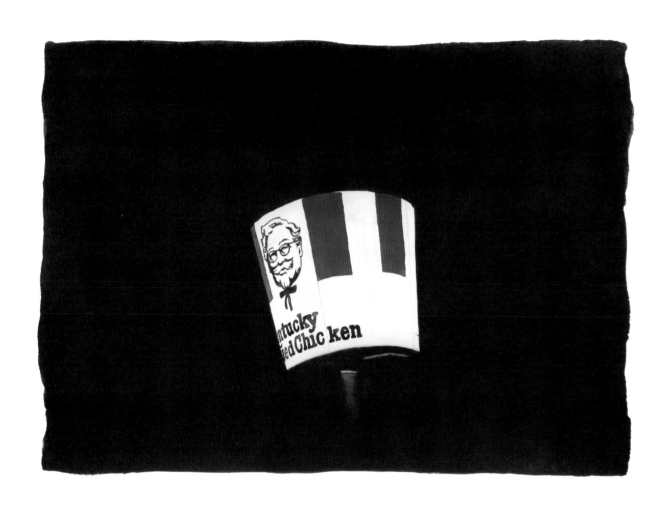

**Untitled**, 2006
Watercolour on paper, 20.3 × 25.4 cm

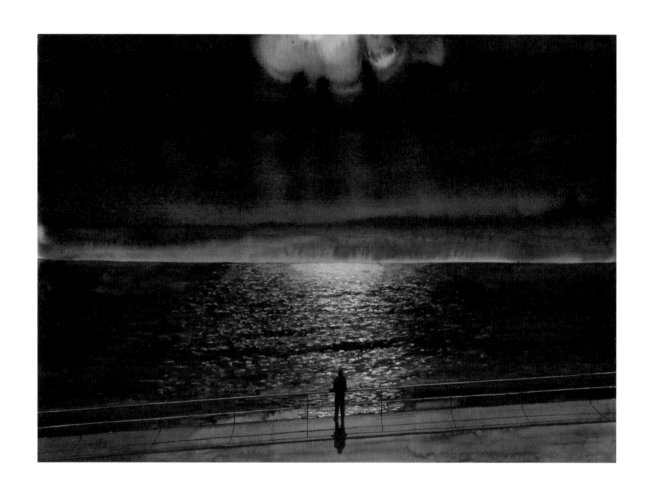

**Figure watching the Moon**, 2006
Watercolour on paper, 44.5 × 61 cm

**Oak Bay Basketball**, 2006
Watercolour on paper, 43.2 × 52.1 cm

## Selected Exhibitions

## Books and Catalogues

**2006**
*The Portrait Now*, National Portrait Gallery, London

**2005**
*Tim Gardner*, Indianapolis Museum of Contemporary Art

**2003**
*Cream 3*, New York, pp. 156–9
*Crosscurrents at Century's End: Selections from the Neuberger
    Berman Art Collection*, Neuberger Berman, New York

**2002**
*Vitamin P*, London, p. 116–19

**2000**
*Waterworks: U.S. Akvarell 2001*, exh. cat, Berndt Arell and Kim Levin,
    The Nordic Watercolor Museum, Skärhamn, Sweden

This book was published to accompany the
exhibition **Tim Gardner: New Works** held at
the National Gallery, London
17 January – 15 April 2007

Generously supported by

With thanks to 303 Gallery, New York,
Stuart Shave/Modern Art, London, and
Tim Gardner

First published in Great Britain in 2007 by
National Gallery Company Limited
St Vincent House
30 Orange Street
London WC2H 7HH

www.nationalgallery.co.uk

ISBN 978 1 85709 398 8
525503

British Library Cataloguing-in-Publication Data
A catalogue record is available from the
British Library

PUBLISHER  Kate Bell
PROJECT EDITOR  Tom Windross
PICTURE RESEARCHER  Suzanne Bosman
PRODUCTION  Jane Hyne and
    Penny Le Tissier

COLOUR REPRODUCTION  Altaimage
PRINTED AND BOUND  Mondadori, Italy

All works by Tim Gardner unless noted
All measurements give height before width

FRONT COVER  **Untitled (Tobi in the
    Landscape)** (page 32, detail)
TITLE PAGE  **Oak Bay Basketball** (page 39,
    detail)
PAGE 6  **Nick on the Prairie, facing into
    the Wind** (page 34, detail)
PAGES 18–19  **Boy on a Bus** (page 23, detail)

PHOTOGRAPHIC CREDITS
All images are © Tim Gardner.
Courtesy 303 Gallery, New York, and
Stuart Shave/Modern Art, London,
unless credited otherwise below:

© bpk / Hamburger Kunsthalle / Elke Walford:
    page 12
© The National Gallery, London: pages 9
    and 14
Private collection © Photo Courtesy
    Stuart Shave/Modern Art, London: page 8